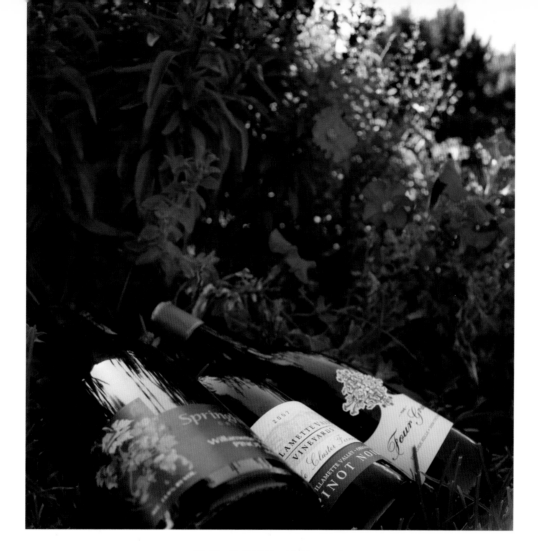

# I LOVE Wine!

A wine enthusiast for years, I have always been fascinated by the actual process of growing grapes and making wine. What other industry requires such a delicate balance of both art and science other than winemaking? Wines of the same harvest and growing region will become completely different in both body and style, as each wine takes on the influences and subtle nuances all around it, from the very soil it was grown in to the winemakers themselves.

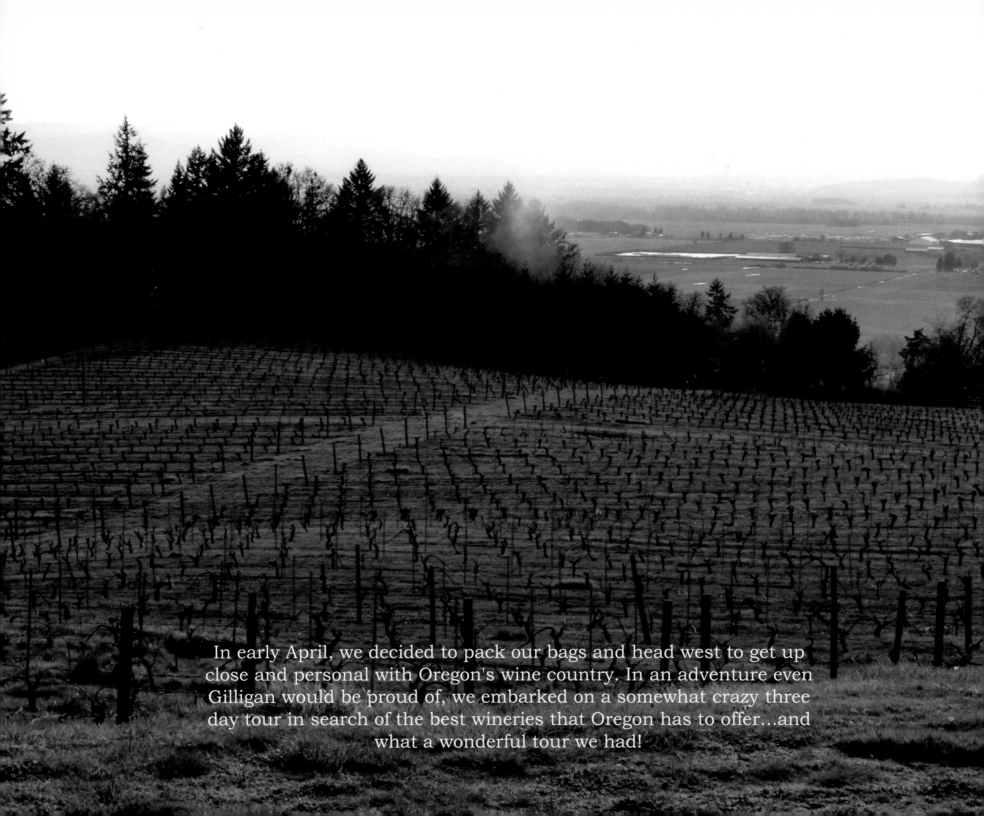

In early April, we decided to pack our bags and head west to get up close and personal with Oregon's wine country. In an adventure even Gilligan would be proud of, we embarked on a somewhat crazy three day tour in search of the best wineries that Oregon has to offer...and what a wonderful tour we had!

So why Oregon wine, you ask?

There are over 300 wineries in Oregon as of the time of this printing and this number continues to grow. While many of these are small, mom and pop family vineyards specializing in one to two types of wine and producing barely 1000 cases a year, others are large, full-scale businesses which make and ship well over 100,000 cases of wine per year, worldwide. Each one, regardless of vineyard size and production, is 100% committed to preserving their land by using sustainable and in some cases, fully certified organic viticulture techniques.

Oregon is fast becoming known both domestically and internationally for producing some of the world's best Pinot Noir, with other fine varieties such as Syrah, Riesling, Chardonnay, Gewürtztraminer, Pinot Gris and Pinot Blanc quickly coming into their own. These are exciting times for the flourishing Oregon wine industry!

3

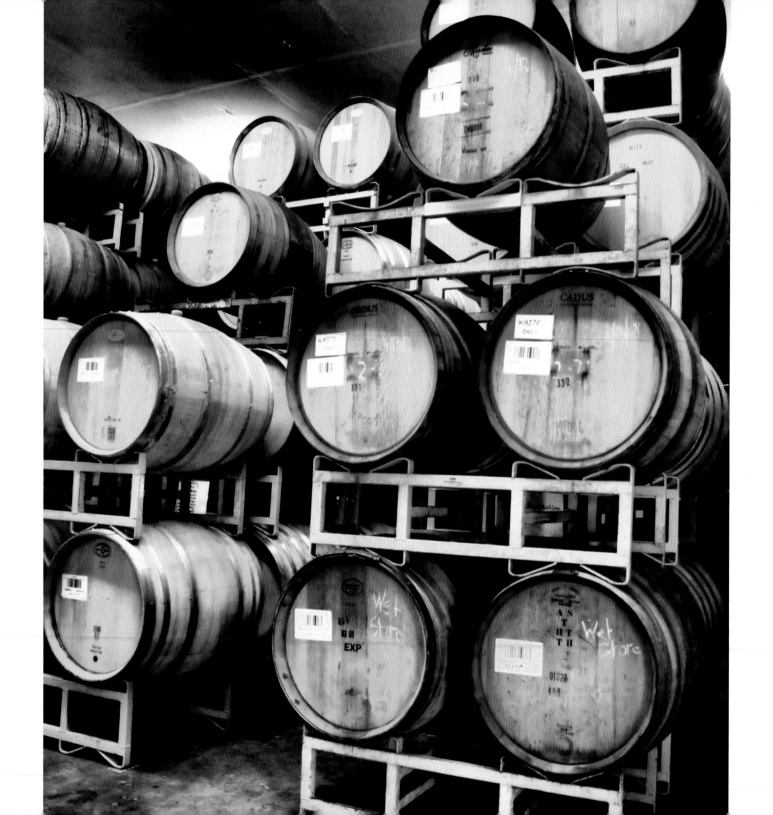

4

Once you have arranged to visit wine country plan on tasting a multitude of fine wines at each stop. And oh, how that wine does flow! Therefore, to be free to thoroughly enjoy the Oregon wine country without endangering yourself or other drivers on the roads, a simple call as you plan your trip is all it takes.

Allow me to be perfectly clear: the first and most important step when visiting the wine country is to designate a driver.

In Oregon, you could do no better than using TourOregonWines.com for all of your chauffeuring needs.

Not only do their drivers have a vast knowledge about the different wineries in the state, they will get you there in the utmost comfort and style with a price and tour designed for every budget.

Give them a call at (866) 861-8738 to schedule your tour today. Choose one of their recommended routes or plan your own itinerary. You can even take the same tour we did - just ask for it!

For now though, come along with us on our tasting tour of some of the true hidden treasures in Oregon…

6

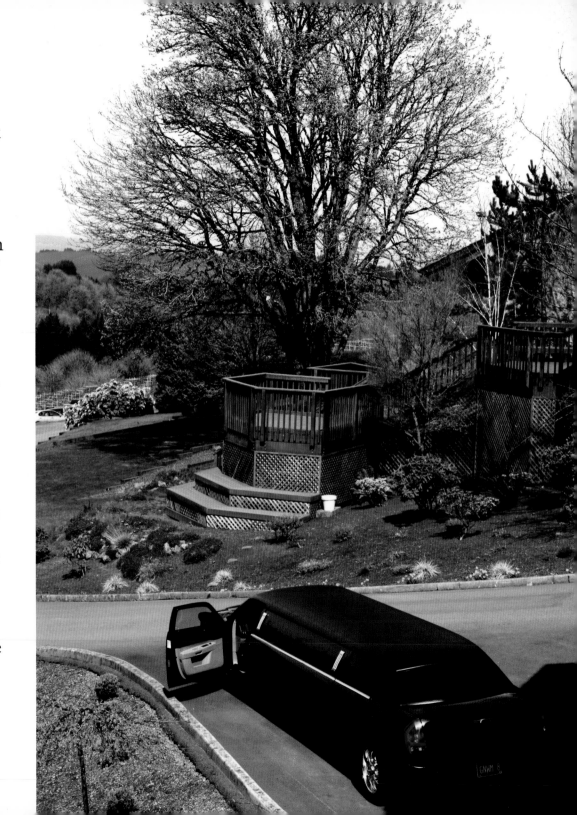

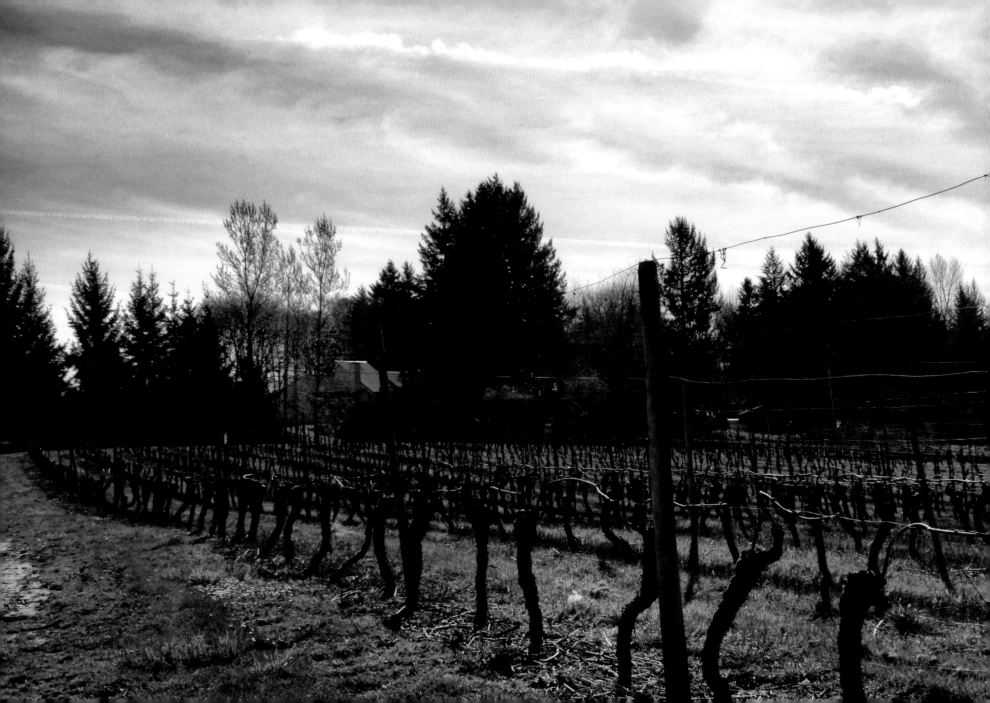

When we first met Mike McLain, he was on his tractor tending to the daily business at Springhill Cellars. Even though he had completely forgotten our appointment (sorry Mike, but you know it's a good story!) he was more than gracious and showed us around the place.

The grounds of this little winery are absolutely breathtaking. The red and white barn, where the tasting room is located, gives the place a very country feel. The barn overlooks the estate vineyard which is planted with 2/3 Pinot Noir and 1/3 Pinot Gris grapes.

Mike and his family made a decision long ago not to grow the winery beyond the current 1,200+- cases it produces each year.

8

"We love making wine and sharing it with people, but not as a means of sustenance. It's more about fun and connection to the land and the seasons, and as a place for our kids and their friends to work in the summer, as I did when I grew up," Mike says.

A real character, Mike likes to joke around with people in the tasting room saying "If they'd had the category, I would have been voted the guy most likely to go into alcohol production." Mike and his family have grown grapes at this location since 1978, when there were only 12 wineries in Oregon.

Today, the family has a second vineyard in the Eola-Amity Hills AVA called simply, McLain Vineyard.

We thoroughly enjoyed sitting on his patio enjoying fine Pinot Noir and the incredible views of the vineyard west towards the Van Duzer corridor.

While soaking in the whole experience, we asked about the gorgeous art on the bottles. Mike pointed down the hill toward the home of neighbor and local Oregon artist, Anna Tewes.

Besides being prominent on all of Springhill Cellars bottles of wine, Anna's art work is also displayed on the winery's website at www.springhillcellars.com. Truly, it is quite spectacular.

Known for their award winning Pinot Noir and Pinot Gris, Springhill's philosophy is simply stated. "Great wines are grown, not made." They choose to put their efforts into producing high quality fruit with absolute minimal interference.

The wines are simply wonderful...consider yourself truly fortunate to bring home a bottle of their fine Pinot Noir!

The tasting room is open weekends from 1pm - 5pm from the first weekend in May through November and by appointment. Springhill is located at 2920 NW Scenic View Drive, in Albany, OR. The tasting room is open weekends from 1pm - 5pm from the first weekend in May through November and can be reached by phone at (541) 928-1009.

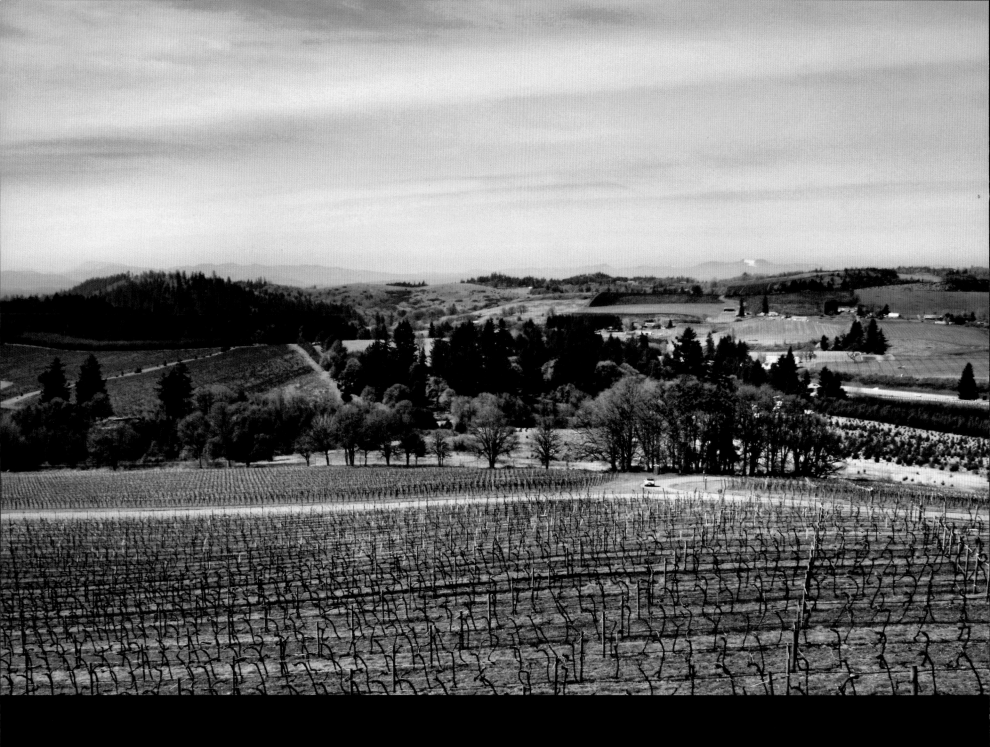

**Willamette Valley Vineyards**

**Turner, OR**

The moment you cross the threshold of Willamette Valley Vineyards property, you can't help but notice the immense hill standing between you and the tasting room at the top. The road would be somewhat scary if it wasn't for the beauty of the vines and fruit all around you. Yet this is only the beginning.

The view from the drive up the hill to Willamette Valley Vineyards is breathtaking but pales in comparison to the scene that awaits you from their deck outside the tasting room. Lush rolling hills of vineyards and green trees seemingly stretch on for miles while the farmland further out contrasts with red soil...it really is something to see. To make the moment even more perfect, take it all in with a glass of one of Willamette's incredible wines in hand. (I heartily recommend the Riesling!)

Founded in 1983 by Jim Bernau, this gorgeous winery site used to be home to a plum orchard and blackberry vines. Willamette Valley Vineyards today is best known for both its fabulous wines--most notably their Pinot Noir, but also for their careful eco-friendly vineyard practices.

With all of their vineyards certified sustainable, LIVE and Salmon Safe, great care is taken in their winemaking practices to have the least amount of impact on the environment as possible. Everything from Willamette's shipping boxes & wine bottles to their corks are recycleable.

In fact, Willamette Valley Vineyards is the first winery in the world to use the Forest Stewardship Councils certified all natural corks. All bottles of WVV wine since July 2007 are packaged with them.

Willamette Valley Vineyards produces 130,000 cases annually with 300 acres of vines of Pinot Noir, Pinot Gris, Riesling and Chardonnay.

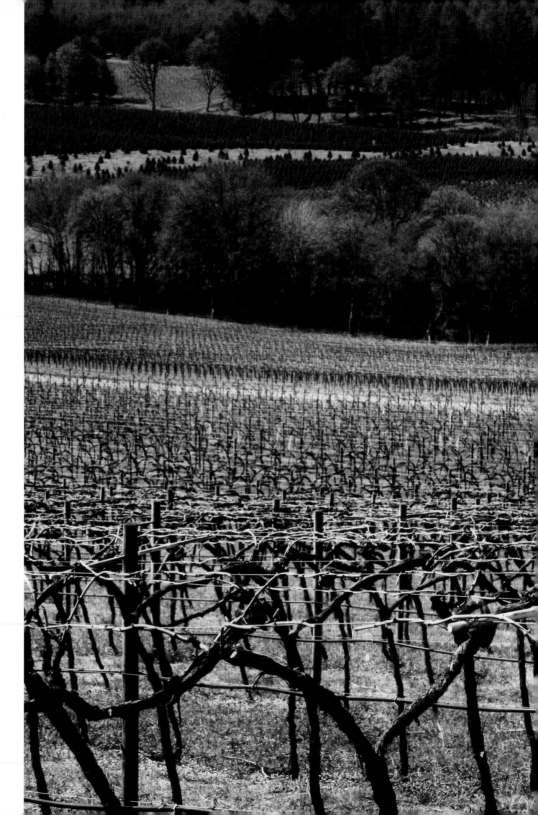

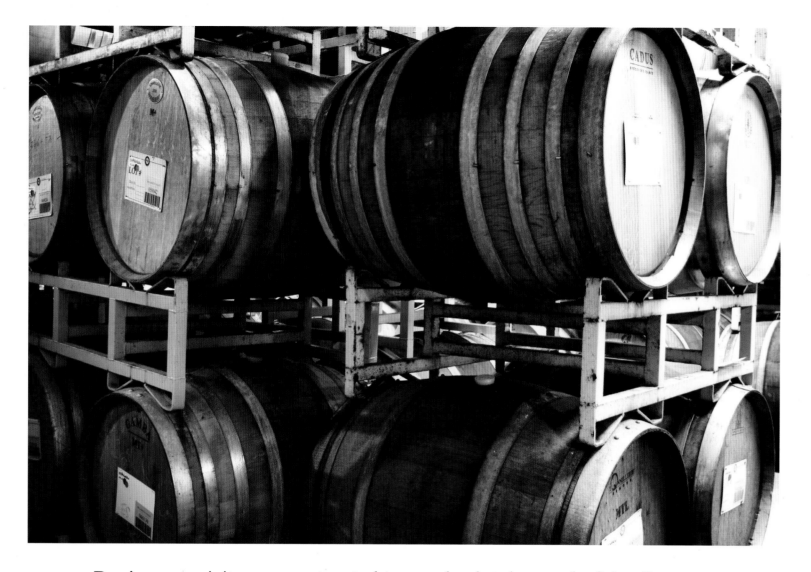

During our visit we were treated to an absolutely wonderful cellar tour and tasting with wine maker Don Crank. Along with the amazing Pinot Noirs we tasted from the barrels, we were allowed a taste of wine maker Forrest Klaffke's handcrafted port. After one sip of that, I am quite certain the sky opened up and a chorus of angels sang.

The vineyard and tasting room is located at 8800 Enchanted Way SE in Turner and is open from 11am - 6pm daily. Visit www.willamettevalleyvineyards.com or call (800) 344-9463 to order online.

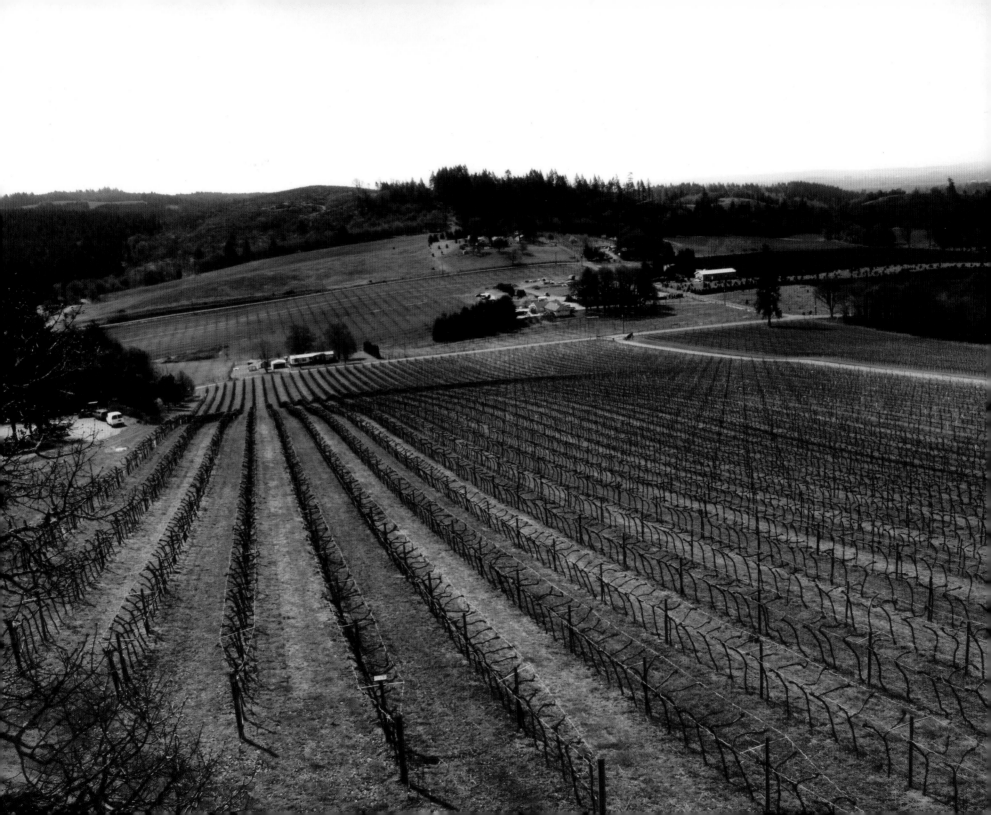

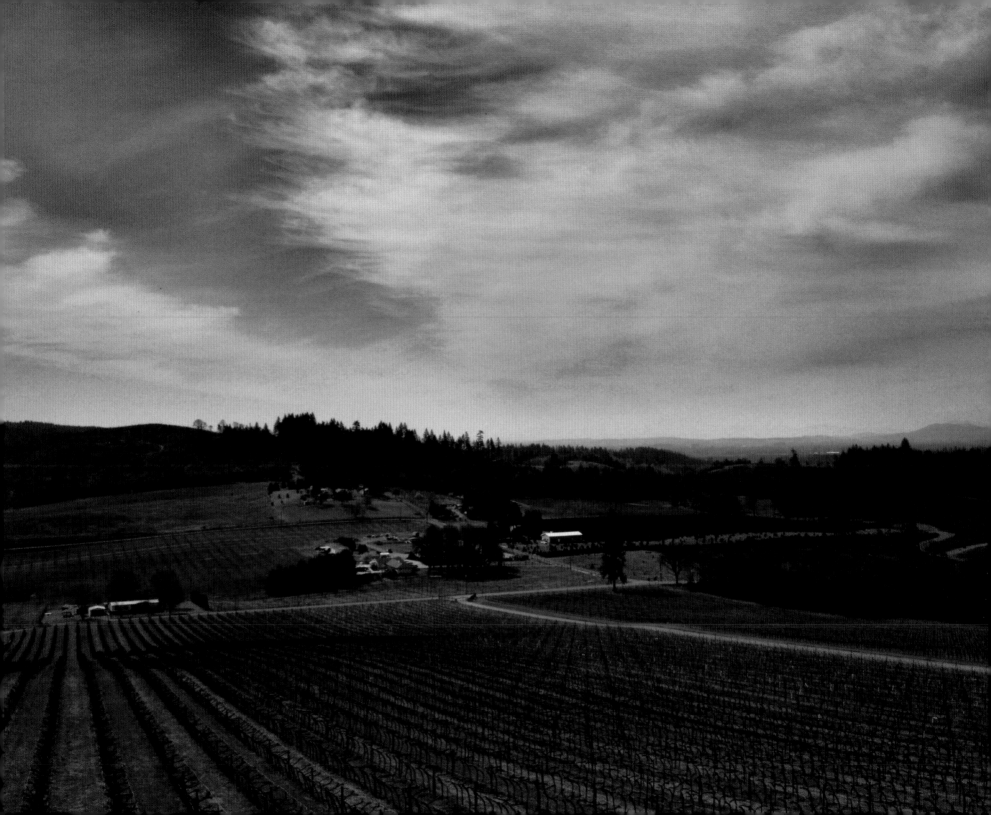

If you were not looking closely, chances are you would miss Honeywood on your first attempt driving through Salem. While set in what would seem to be an industrial setting, Honeywood is actually a gem just waiting to be discovered. With an intensely stocked gift shop and a literal WALL of wines, this winery is not to be missed.

Known as Oregon's oldest winery, Honeywood was founded in 1933 by Ron Honeyman and John Wood and was licensed on the very first day that winemaking became legal following Prohibition. Starting with primarily fruit brandies, Honeywood moved into producing fruit wines during the second world war. Though located in the heart Salem, this unique winery is just minutes away from the prime cool-climate wine grape growing AVA Willamette Valley, cane berry fields and luscious fruit orchards.

Honeywood is one of the few wineries that produces a particularly large
offering of fruit wines in addition to varietals that are absolutely fantastic.
Their incredible gift shop is full of anything a person could want and more,
with enough varietal and fruit wines to fill an entire wall of the shop.
Honeywood is the place to stop in Salem!

Aside from their awesome fruit wines (the Loganberry will knock your socks off!), Honeywood stands out from other wineries in the region by also producing fabulous wines from three 100% American grapes: Concord, Muscat and Niagra. These wines are truly spectacular, very different and well worth a taste.

Honeywood's tasting room is open from Monday-Friday 9am - 5pm Saturday 10am - 5pm and Sunday 1pm - 5pm at 1350 Hines St SE in Salem. You may also place an order on their website at www.HoneywoodWinery.com or call (800) 726-4101, though you absolutely must make it a priority to visit.

# HONEYWOOD WINERY

## ...ARIETAL

| | | |
|---|---|---|
| ...et | Chardonnay | Blush |
| ...al Foch | Pinot Blanc | Niagara |
| ...ah | Pinot Gris | Muscat |
| ...oir | Gewurztraminer | |
| ...t Noir | Muller Thurgau | |
| ...Red | Riesling | |

## SPECIALTY

| | |
|---|---|
| Apricot Supreme | Pomegranate Supreme |
| Blueberry Supreme | Raspberry Supreme |
| Peach Supreme | Strawberry Supreme |
| Golden Pineapple | Honey Mead |
| Cranberry Supreme | Honeysuckle Peach |
| Cranberry L'Orange | |

## FRUIT...

| | |
|---|---|
| Rhubarb | Pear |
| Loganberry | Plum |
| Blackberry | Red C... |
| Marionberry | Raspb... |
| Boysenberry | Cherr... |
| Triple Berry | Creme... |

The drive out to Witness Tree Vineyards is breathtaking, with incredible scenery, rolling hills and lush vineyards enveloping you.

Witness Tree is a small producer of premium-quality Pinot Noir and Chardonnay wines that are 100% estate bottled (meaning every grape that goes into a Witness Tree wine has been grown on their property). Producing approximately 6,000 cases per year, the winery makes Pinot Noir, Viognier, Pinot Blanc, Chardonnay, Dolcetto and Sweet Signe, a sinfully sweet dessert wine named after the owner's granddaughter.

The vineyard is located nine miles northwest of Salem and takes its name from an ancient oak tree used as a surveyor's landmark in 1854, during the Oregon Trail era. The tree was used to mark the Northwest corner of the original Donation Land Claim No. 51 and - believe it or not - it still stands today at the top of the vineyard. Picnic tables and a nice hiking trail to the tree makes for a great afternoon outing.

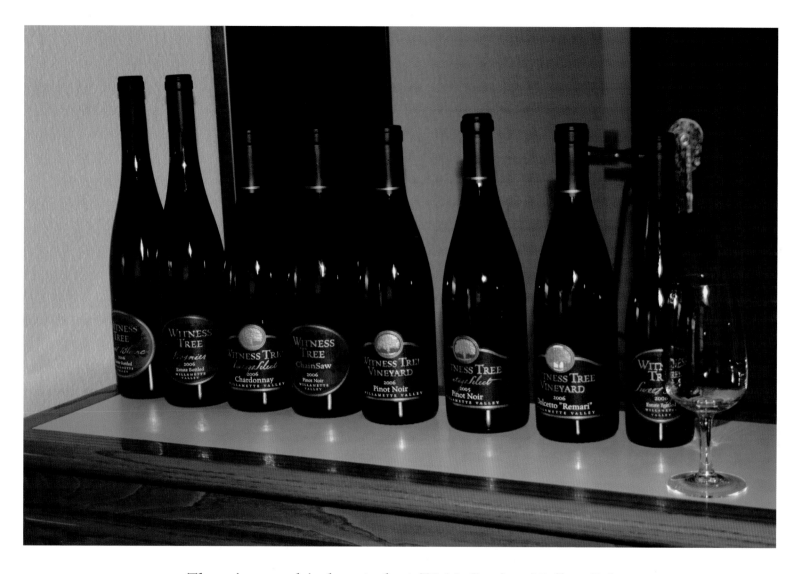

The vineyard is located at 7111 Spring Valley Rd outside of Salem. Wine may also be purchased at www.witnesstreevineyard.com or by calling 1-888-GR8T-PNO. Tasting room hours vary, visit the website for details.

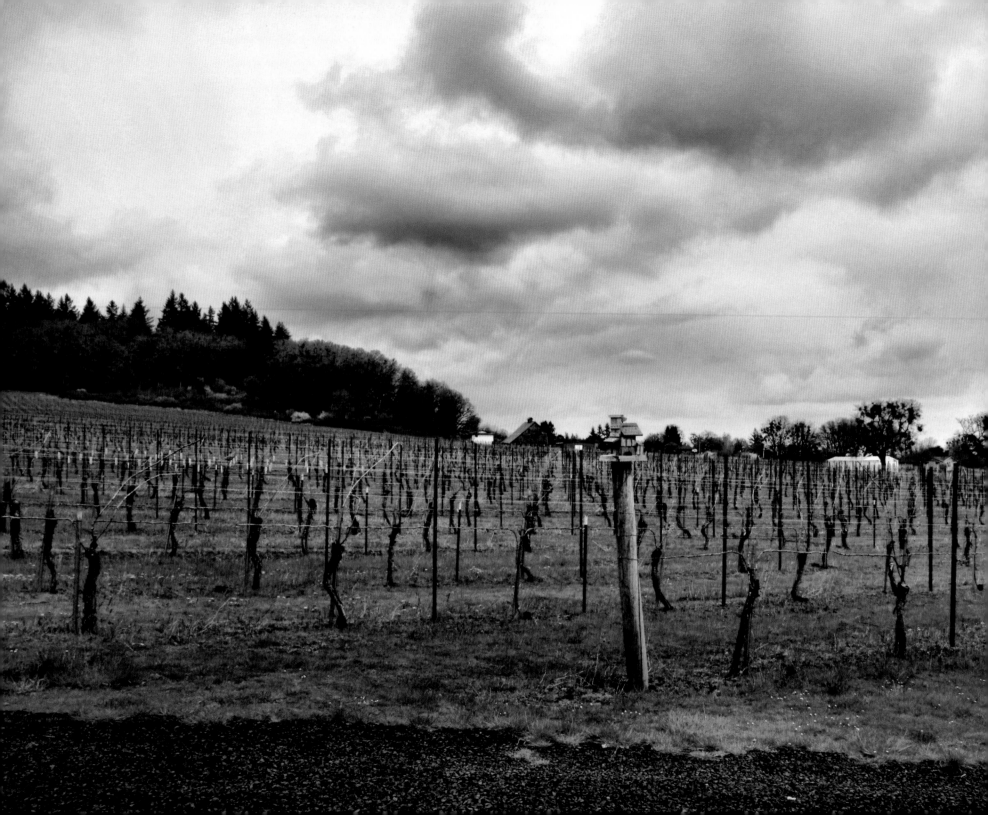

Pulling up to Airlie, we were greeted by two beautiful dogs. After saying hello to the friendly pups, I glanced up and was overcome by the absolutely spectacular view; it was as if we had stepped out of Oregon and into Hawaii. The trees all had a tropical aura about them, and the clouds were virtually nonexistent so as to open the floodgates of sunlight.

After several hours of exploring many of Oregon's hidden treasures, a level of exhaustion was setting in. Yet, there was something inherently tranquil about this particular locale. Flowers were in bloom, the lake was virtually undisturbed (save for the splashing of those playful dogs), and the architecture was beautifully simplistic.

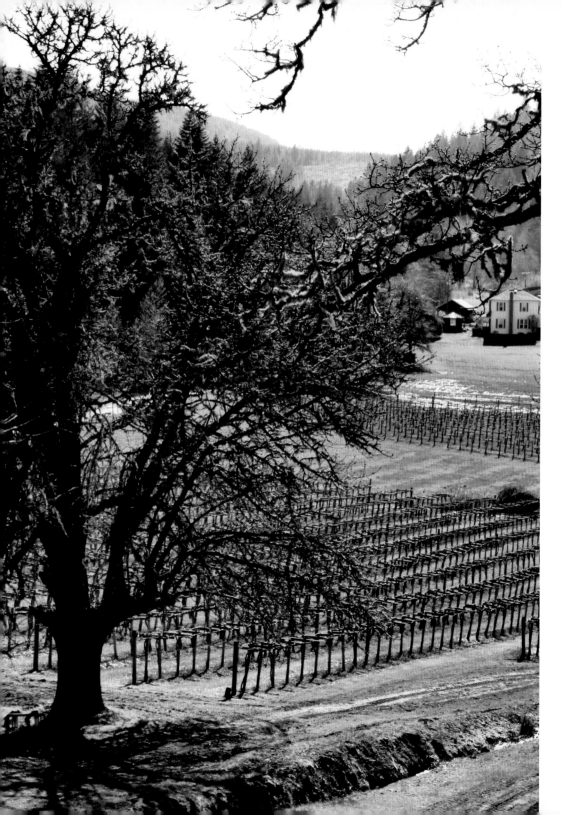

As luck would have it, we had shown up quite a bit later than planned and our contact had already left for the day. At most other places, circumstances like this would leave us out of luck. Airlie was different, though. Elizabeth, the wine maker, took the time to show us around, and then gave us free reign to wander aimlessly and explore (or in my particular case, photograph) everything in sight. Of course, I took more pictures of the dogs than anything else. They were gorgeous animals, and I couldn't resist...

Aside from my brief stint as a canine glamour photographer, I did have time to sample their excellent selections while enjoying the breathtaking scenery and friendly people. All in all, this was a very nice stop and I look forward to returning to Airlie soon.

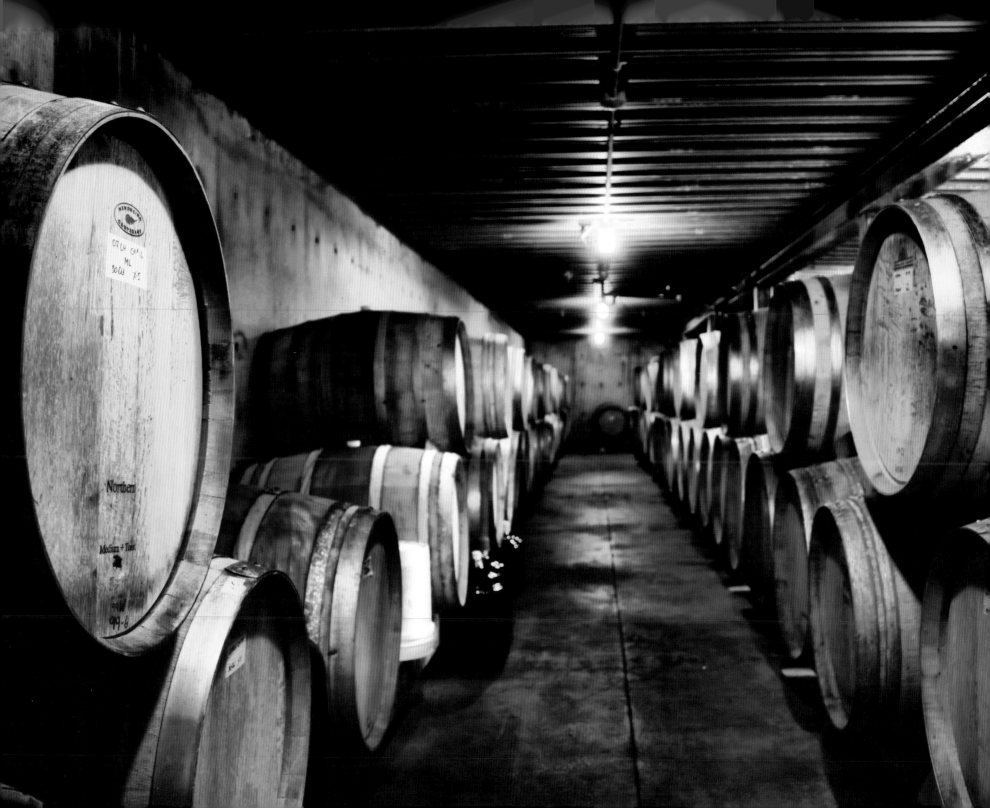

Airlie Winery is located at 15305 Dunn Forest Road in Monmouth and the tasting room is open Saturday and Sunday from 12pm - 5pm. A visit to the tranquility of their property is recommended for recharging the soul, however you may also order Airlie wine online at www.airliewinery.com or via phone at (503) 838-6013.

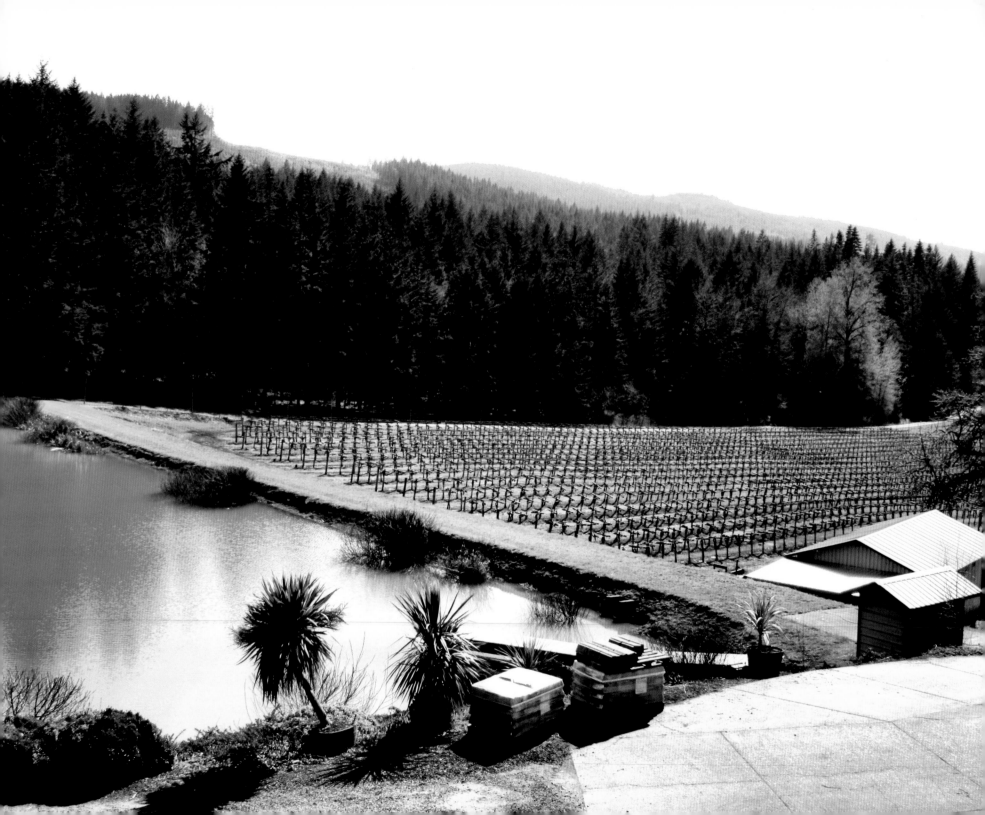

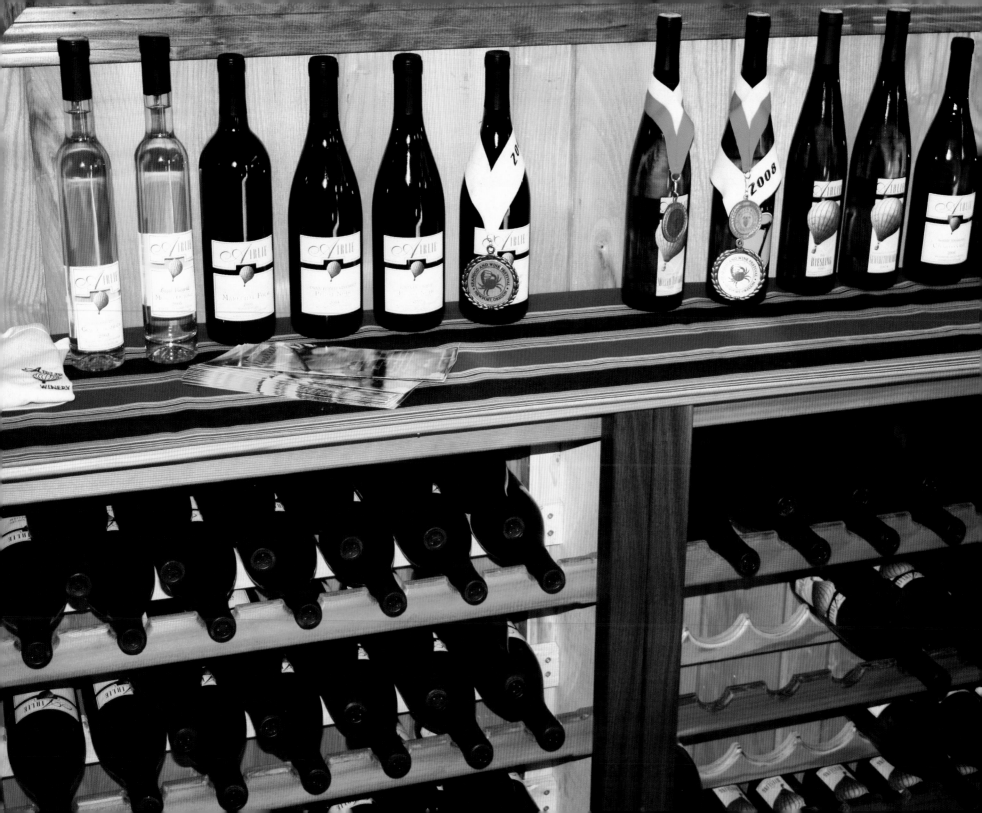

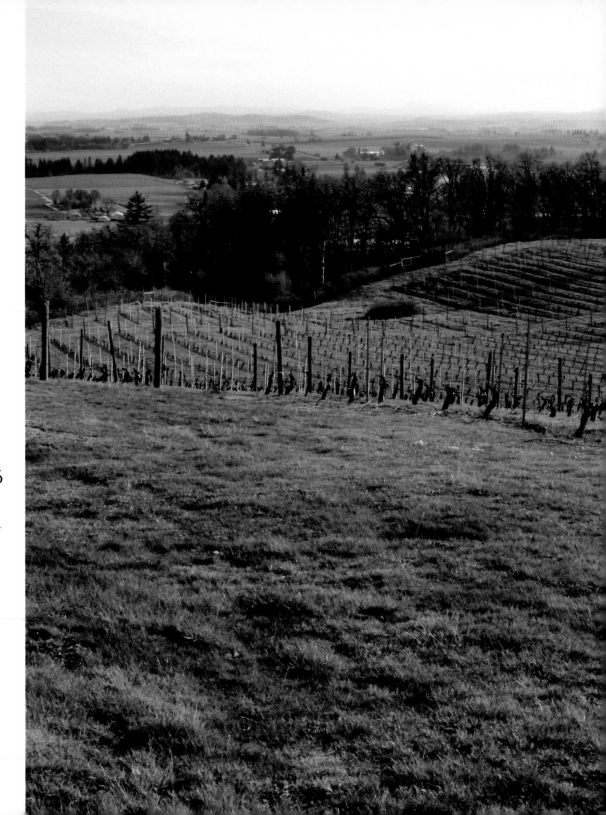

As you approach Amity Vineyards you can't help but be swept away by the beauty of the area. Situated atop the Eola Hills, Amity's tasting room and picnic area offer a spectacular panoramic view of the Oregon Coast Range. This beauty is what first prompted Myron Redford and Janis Checchia to purchase the land and the vineyards in 1974. And who could blame them? If you could work everyday in this beautiful setting, wouldn't you?

Amity has always been a family affair. Myron built the winery himself in 1976 and has been making wine there ever since. Myron's wife, Vikki, first worked in Amity's lab for 5 years, helped with winery public relations and has entertained and cooked for winery guests over the last 28 years. Myron's brother Stephen was even involved for several years as cellarmaster.

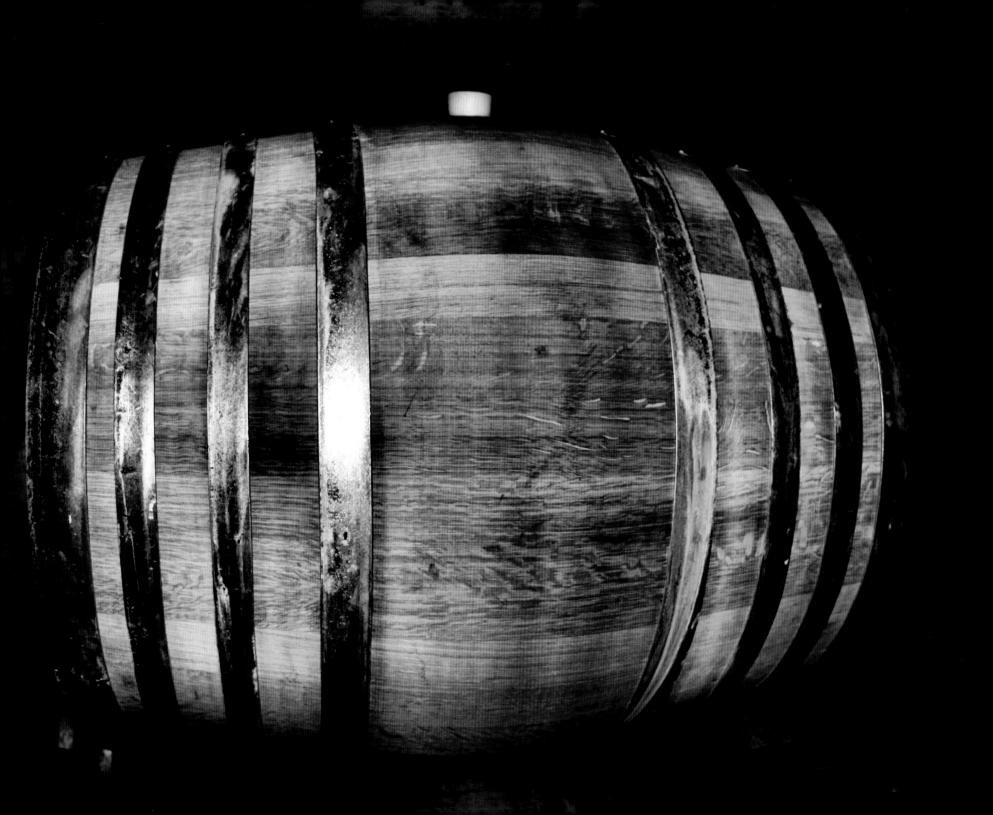

Always a bit ahead of the curve, Amity produced Oregon's first organic, sulfite-free Pinot Noir back in 1990, dubbed ECO-WINE. Continuing that trend, the winery has added 3 new ECO-WINES in 2007: a Gamay Noir, Marechal Foch and a Chardonnay/Pinot Blanc blend.

It was such a treat to meet Myron and Vikki during our tour. In just moments with them, you are instantly drawn to the passion they have for this land that they own and work on, their love for the wine and the process of making it and of course, the finished product. Along with their award winning Pinot Noir and Eco-wines, the Wedding Dance Riesling is fabulous as well as their Late Harvest Riesling--herein to be known as the NECTAR OF THE GODS.

Amity's 2006 ECO*WINE Willamette Valley Pinot Noir won a gold medal at both the Northwest Wine Summit and the Oregon State Fair. This is the first time the state fair has awarded and Organic and No Detectable Sulfites Pinot Noir with a gold medal.

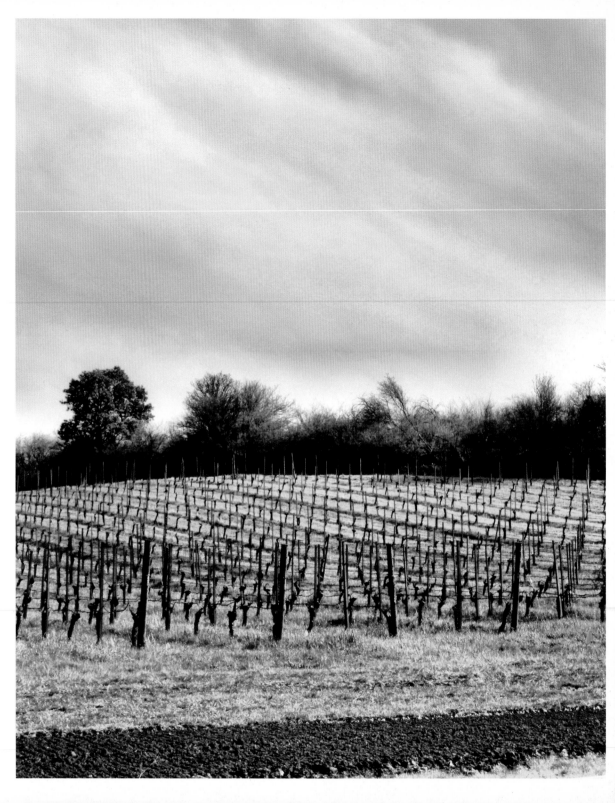

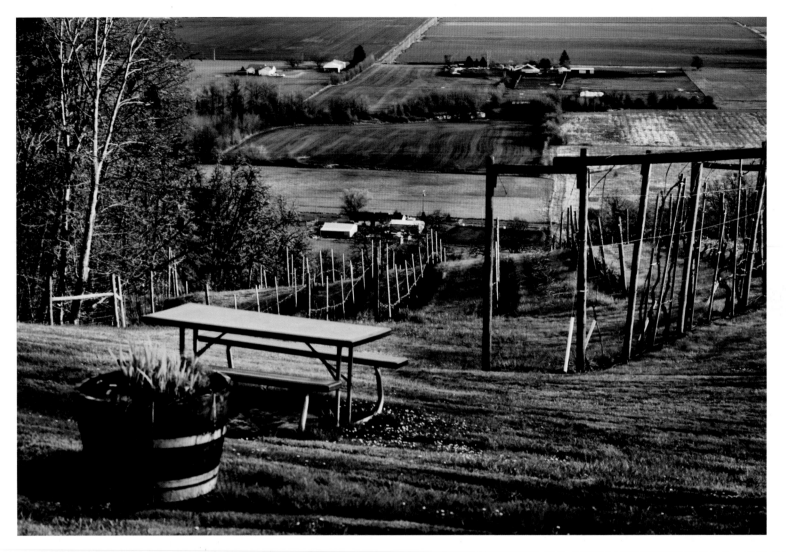

Amity Vineyards is located 1 mile northwest of the town of Amity off of Highway 99W. The tasting room is open daily, 11am - 5pm, June through September and 12pm - 5pm October through May. If you are unable to visit in person, you may order Amity Vineyards wines online at www.amityvineyards.com or by phone at (503) 835-2362.

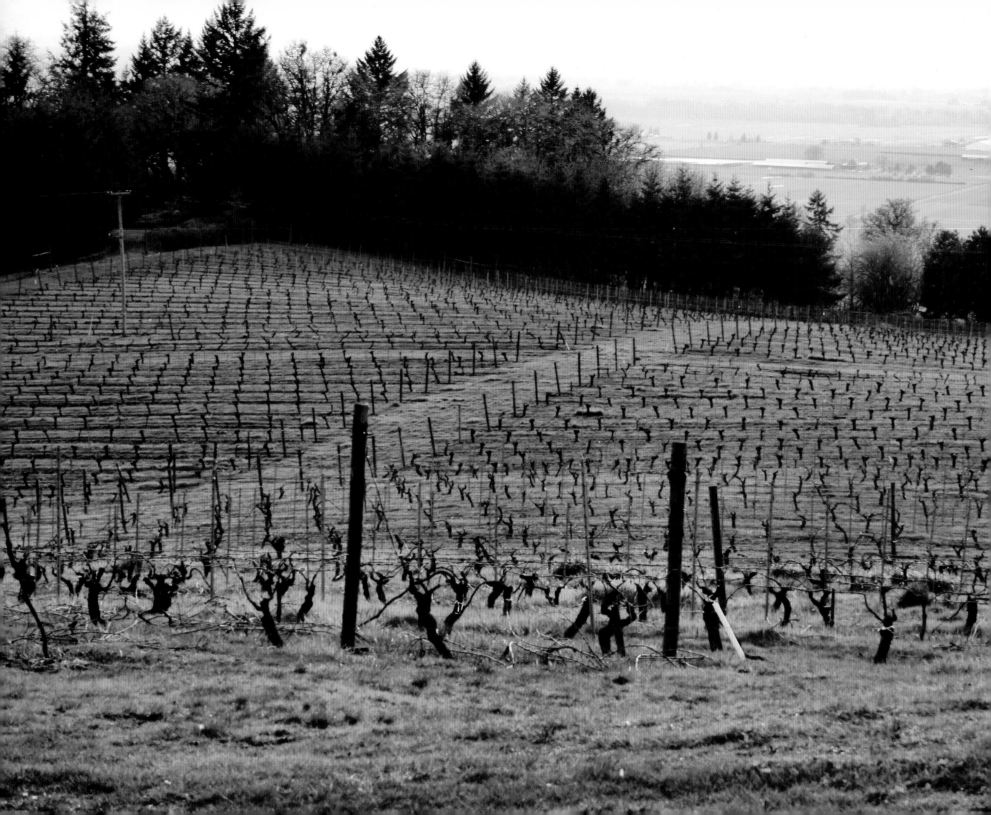

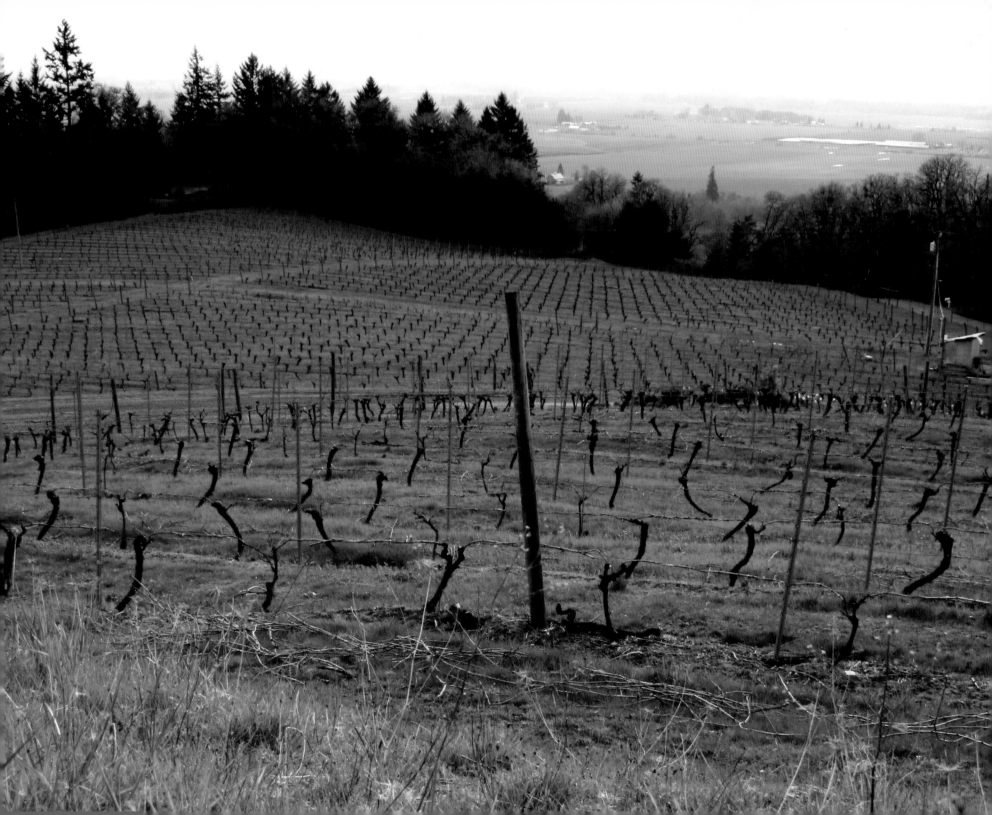

46

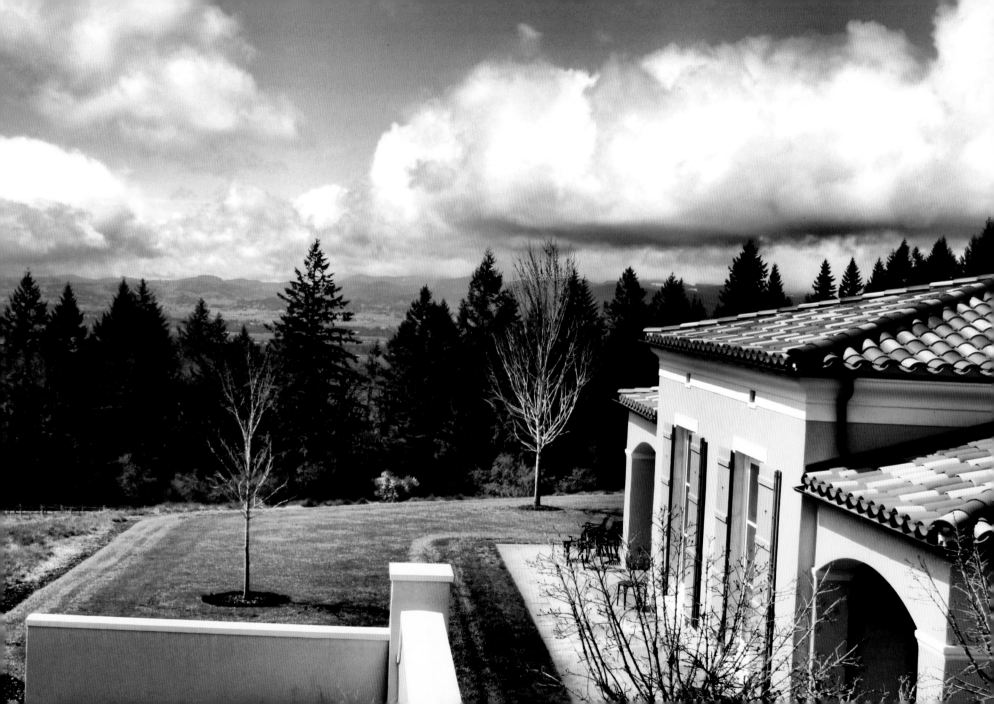

Once we arrived at Domaine Serene we were immediately struck by their beautiful Tuscan style building topped with Mediterranean tiles and the breathtaking vineyard view all around. The tasting room is very elegant and well appointed, with much attention to detail.

Ken and Grace Evenstad designed Domaine Serene to stand out from all others in not only their high quality wines but also in their architecture and experience. The winery focuses on crafting world class Pinot Noir. By limiting production to approximately 16,000 cases per year they maintain the exceptional quality that is the Domaine Serene hallmark, well worth the same higher prices commanded by the great wines of the Burgundy region.

A bottle of their Monogram Pinot Noir, billed as the epitome of American Pinot Noir and a blend of estate grown grapes from hand selected lots, currently sells for $225 a bottle. The winery has also recently crafted a rather amazing new white wine from Pinot Noir grapes called Couer Blanc - definately worth a taste. Domaine Serene is located at 6555 Hilltop Lane in Dayton. The tasting room is open Wednesday - Monday from 11am - 4pm. To shop online, visit www. domaineserene.com or contact them by phone at (866) 864-6555.

Vista Hills Vineyard & Winery

Dayton, OR

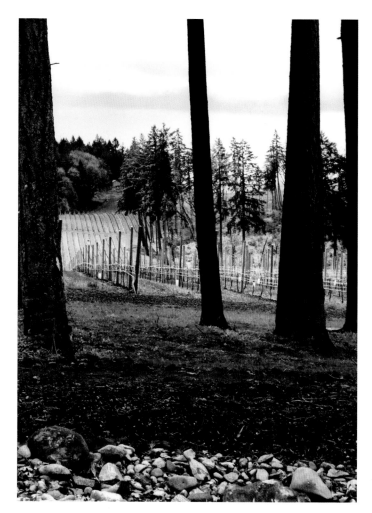

Pulling up to Vista Hills, a beautiful wooden building came into view, framed by a vast forest-like landscape. Trees stood straight up as if to allow one to see past to the rolling hills. A small lake laid out front while a small waterfall & fountain flowed into it. Even when the sky turned overcast, the scenery remained breathtaking. The interior of the building was spacious and welcoming, and successfully conveyed a kind of transcendent mood befitting of the whole experience. This beautiful tasting room, appropriately named the Treehouse, was opened in November 2007.

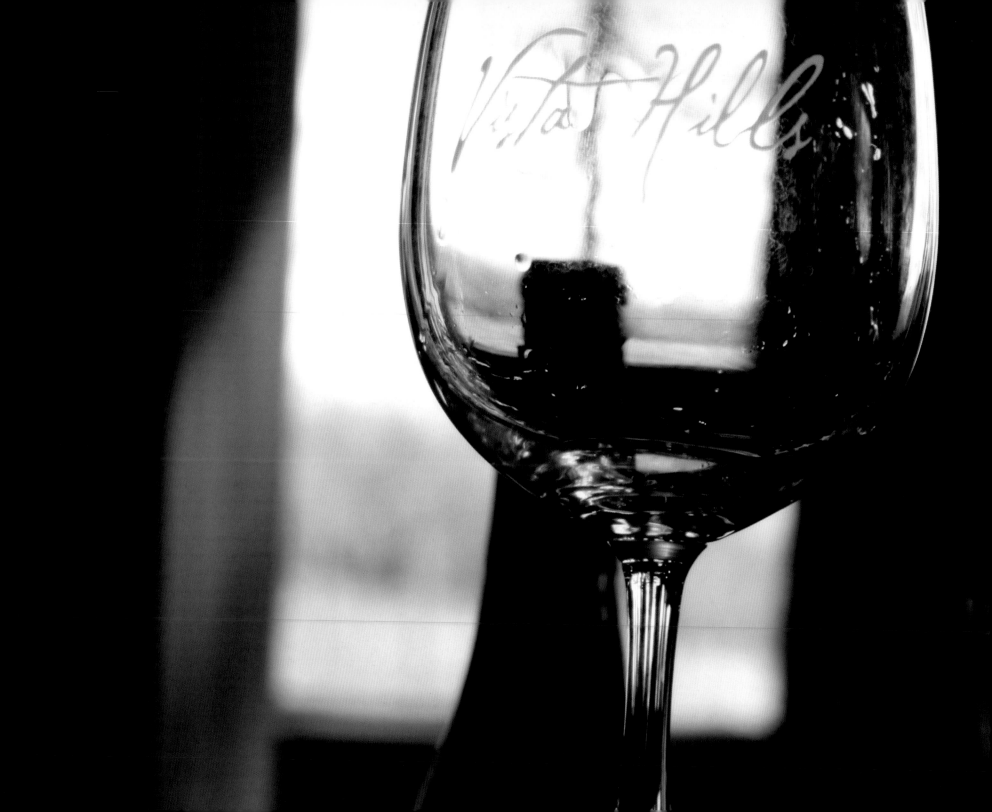

Complimenting the gorgeous setting was the friendly tasting room staff, people as fantastic as the wine they freely poured. In fact, their Pinot Gris remains a fond memory if not a newfound addiction. You truly must visit Vista Hills whenever you're in the area - you won't be disappointed.

The Treehouse tasting room is located at 475 Hilltop Lane in Dayton. Their summer hours are 12pm - 5pm daily or by appointment. You may contact them by phone at (503) 864-3200 or visit them online at www.vistahillsvineyard.com.

Imagine being planted in the middle of a vineyard for an overnight stay like none other. While there, you are treated to fabulous views, incredible food and impeccable service. That experience is Wine Country Farm Cellars in Dayton, OR.

Not only is it an amazing boutique winery, but Wine Country Farm is also a full service bed and breakfast. Rest in a spacious B&B suite with 180 degree vineyard views, relax in the large living area complete with piano, and enjoy their fine wines made in very small quanities completely on site. Wine Country Farm also has a large house available for rent on another parcel of vineyard land not far from the winery.

While there, you can visit their gorgeous Arabian horses in the beautiful old barn and even take a horseback wine tour of the area departing directly from Wine Country Farm. Finish your perfect day up with a massage by their on site certified massage therapist and a late night soak in the hot tub.

The entire staff of Wine Country Farm will delight you from the very first moment of your visit. This experience is not to be missed! Wine Country Farm is located at 6855 NE Breyman Orchards Road in Dayton. Contact them for reservations at (503) 864-3446 or visit them online at www.winecountryfarm.com.

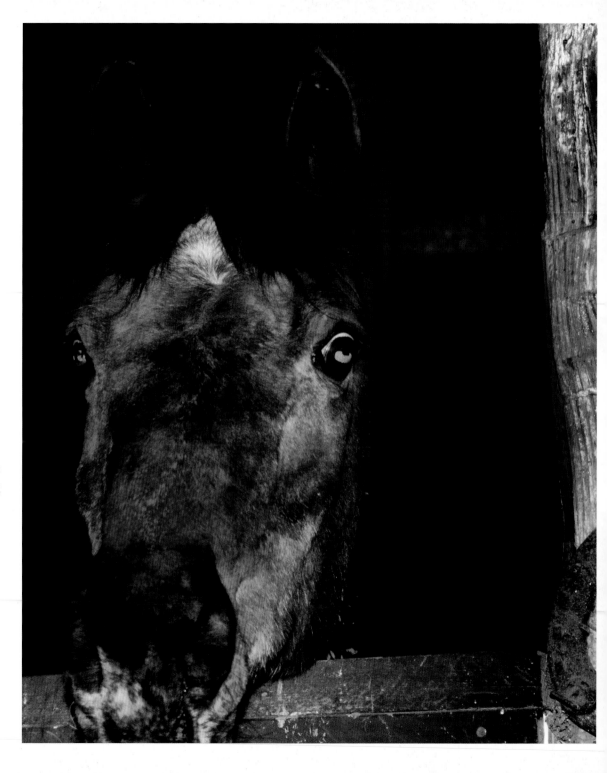

Sokol Blosser

Dundee, OR

Being a somewhat closet fan of Oregon's wine history, I was beyond excited to re-visit Sokol Blosser in Dundee for the first time in nearly a decade. Winery founder, Susan Sokol-Blosser has played an important part in shaping and helping develop the Oregon wine industry while being a champion of environmentally friendly winemaking and sustainable practices in the industry. In fact, in 2007, Sunset Magazine honored both Susan and Sokol Blosser with their prestigious "Green Winery of the Year" award.

Alison Sokol-Blosser, co-president and daughter of Susan and her former husband, Bill Blosser, met us at the winery. Even though we were running late, she was gracious enough to take us on a tour throughout the grounds. Alison explained how the winery strives to create wines that are of world class quality while being made with sustainable, environmentally conscious methods.

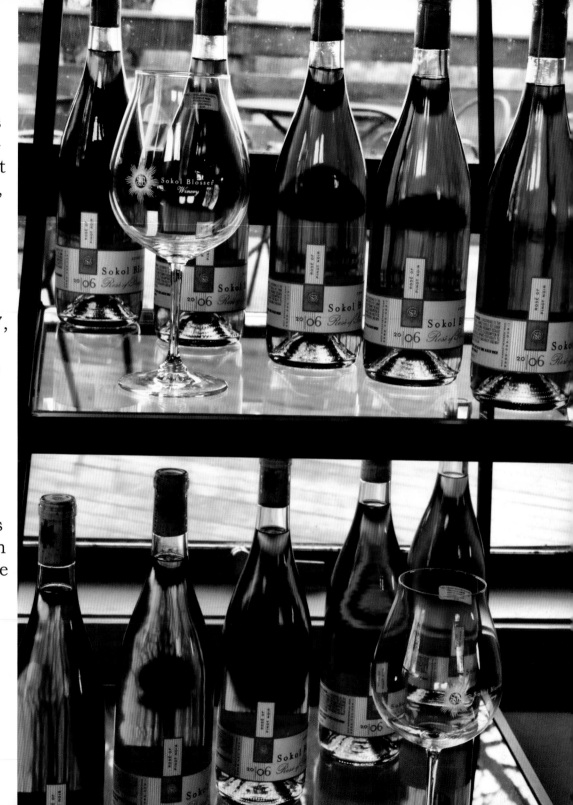

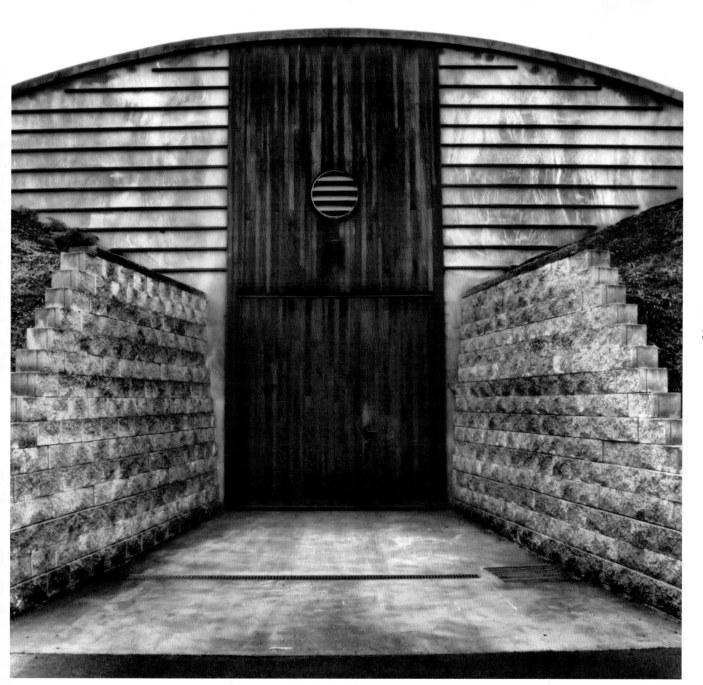

In 2005, Sokol Blosser earned full organic certification. They were the first winery in the country to earn the LEED (Leadership in Energy and Environmental Design) 2.0 Silver Level certification for their underground cellar. They are LIVE certified as well as Salmon Safe, making Sokol Blosser one of the country's most environmentally friendly wineries.

65

We toured the underground cellar and the wineries beautiful grounds. Not only does Sokol Blosser have a large deck, but also plenty of tucked away places cleverly appointed with tables and chairs, making the winery a perfect place for an inpromptu picnic. After your picnic, be sure to enjoy a stroll of the grounds because the views overlooking the beautiful rolling Red Hills of Dundee are truly quite incredible.

Sokol Blosser's wines are fantastic. Should you find yourself having a picnic on the grounds, I heartily recommend the Sokol Blosser Pinot Noir Rose--which is a beautiful bottle, a wine of gorgeous color and fantastic taste made only more perfect by enjoying it at one of the many scenic picnic areas that overlook the vineyards. It is a spectacular experience.

Sokol Blosser's tasting room is located at 5000 NE Sokol Blosser Lane in Dundee and is open daily from 10am - 4pm. You can contact them by phone at (503) 864-2282 or order online at www.sokolblosser.com

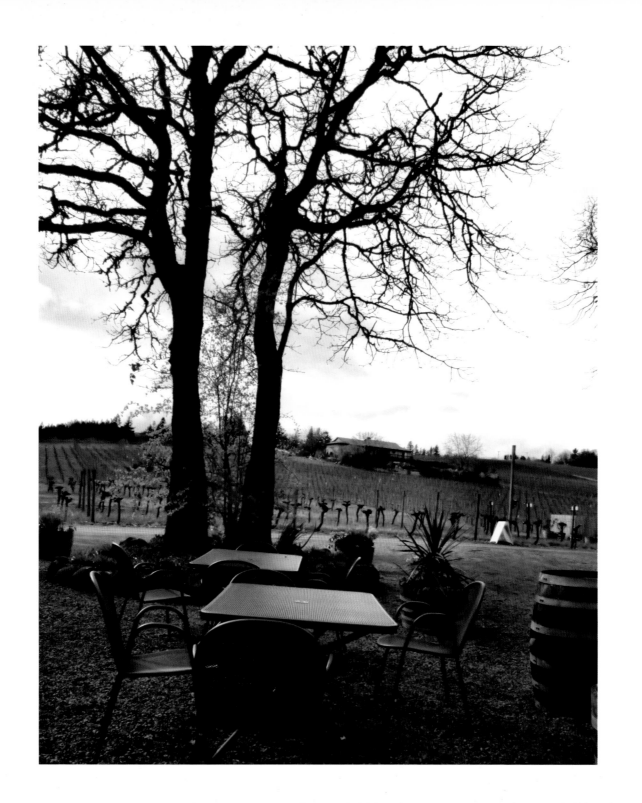

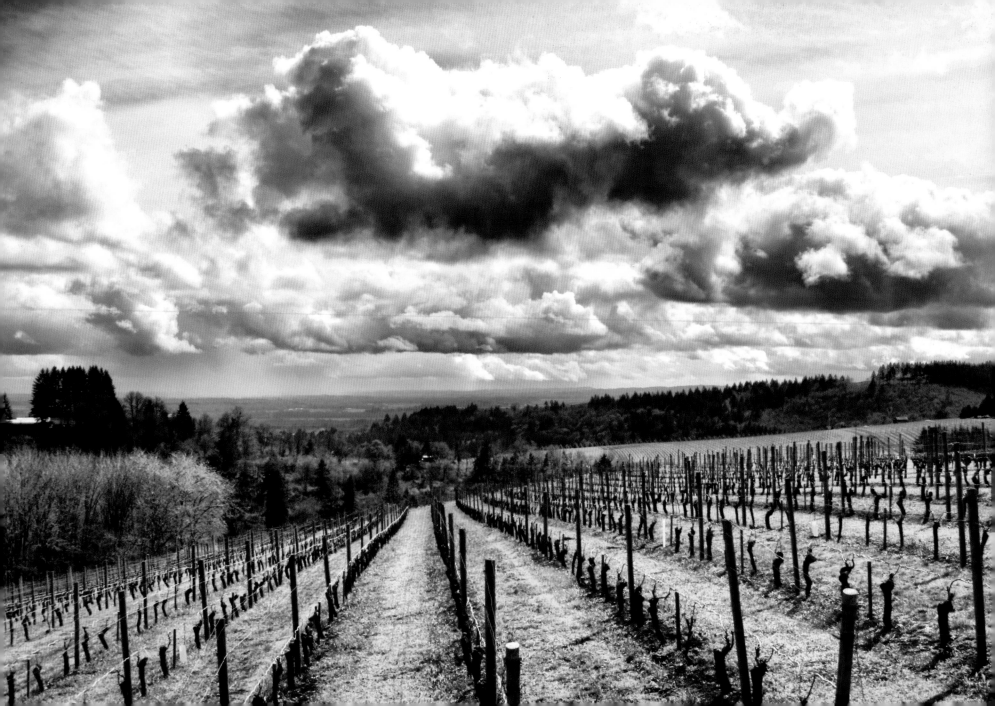

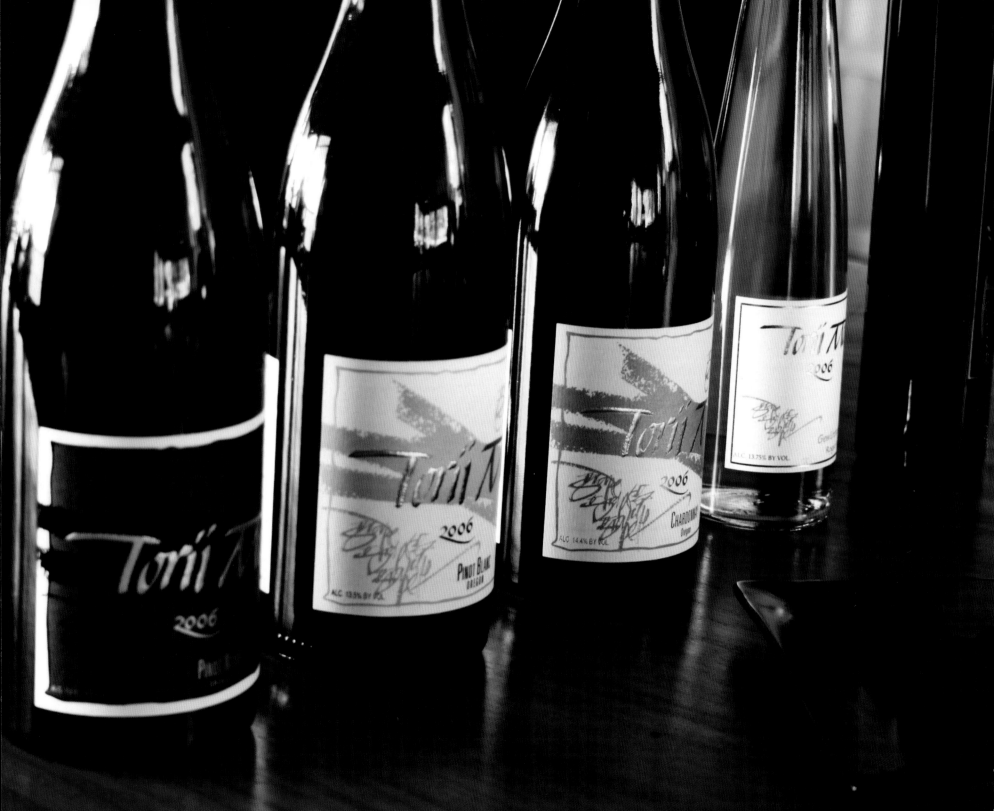

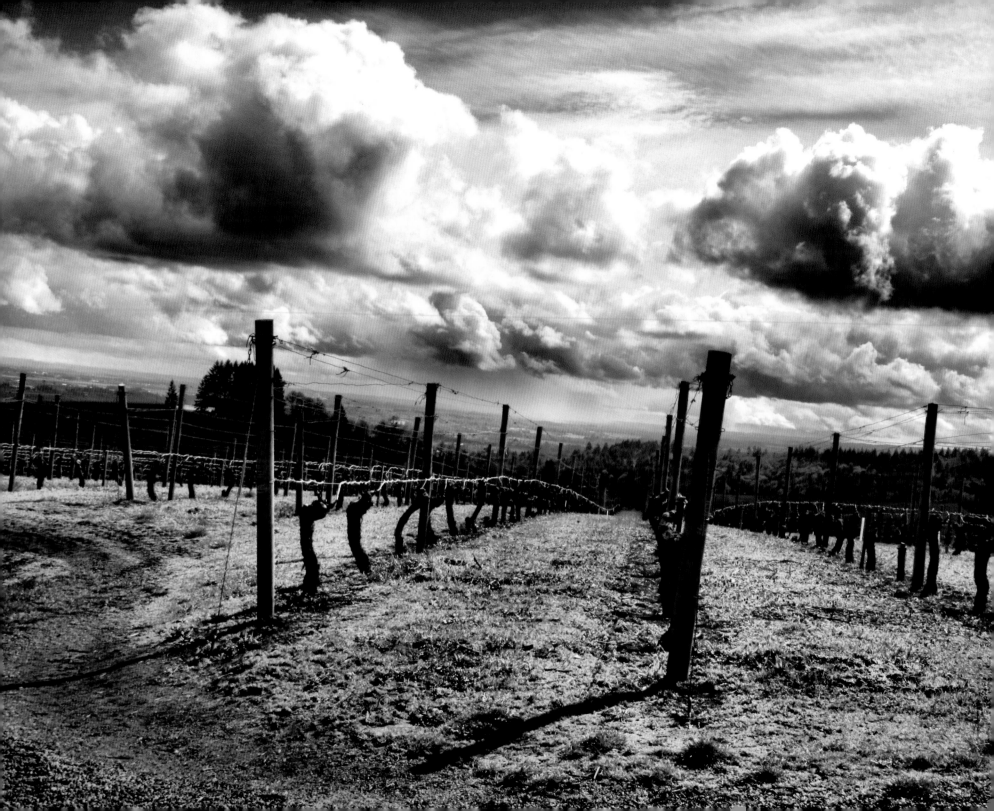

Torii Mor makes you believe wholeheartedly in the possibility that heaven can be experienced in a fine bottle of wine. "Beautiful", "incredible", and "awesome" do not fully capture the elegance of this winery. The view of their Japanese gardens and their majestic Olson Estate Vineyards on site is only eclipsed by their impeccable wine.

Torii Mor's tasting room is small and friendly, limiting visitors to 6 at any given time to maintain the intimate setting. We were fortunate enough to be treated to an executive tasting at Torii Mor with owner Margie Olson. At the risk of sounding superfluous, this experience catapulted us into a whole other world.

Inside her private vineyard home, we sat at a long, exquisitely set table adorned with exceptional wines and a fine selection of cheese. Each bottle we tasted was more incredible than the last and was expertly poured for us by a very attentive assistant.

Adding to the total experience, Margie delighted us with a story and description of each wine we tasted. This tasting was a once in a lifetime experience from start to finish, and I highly recommend you take the time to make this happen for you. To set up your own private tasting experience, contact Torii Mor at (800) 839-5004.

The tasting room is open from 11am - 5pm daily and is located at 18365 NE Fairview Drive in Dundee.

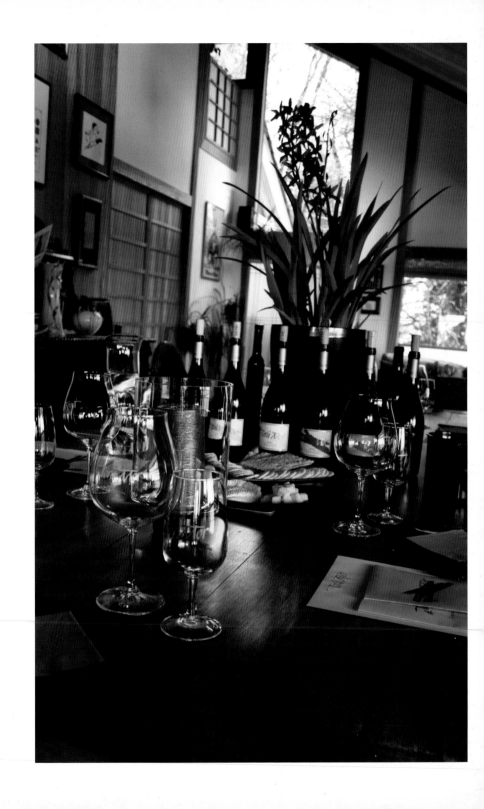

**Erath Winery**

Dick Erath began making wine from Oregon grapes in 1967 when he first recognized the grape growing potential of Oregon's Willamette Valley. From there he went on to help start the Oregon winemaking industry (along with 1/2 dozen or so other Oregon wine country pioneers) and build it into one of the most exciting wine producing regions in the country.

He purchased his first vineyard site in the Dundee Hills in 1968 and in 1972 produced his first commercial wine of 216 cases. Since then, Erath has played a major role in championing Oregon's wine industry and in solidifying its reputation as a worldwide leader. In fact, Erath's very first vintage in 1972 produced a Pinot Noir and Riesling that won Gold Medals from the Seattle Enological Society.

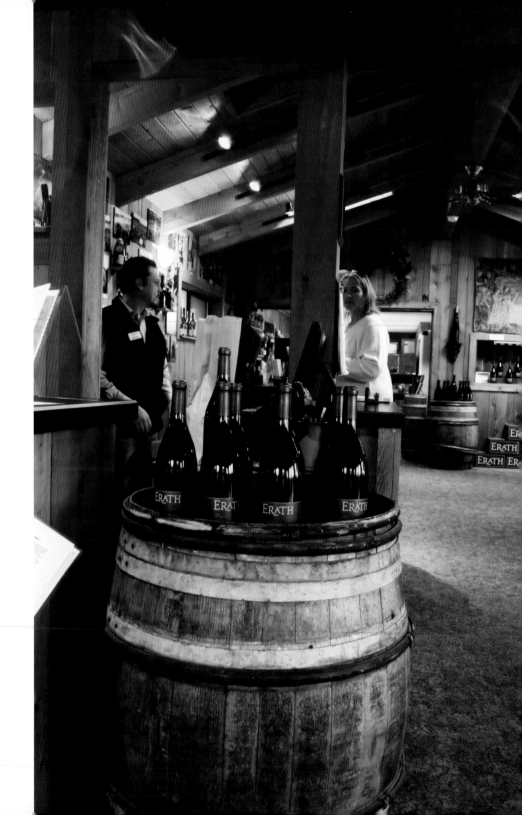

Today, as Erath Winery - now owned by Ste. Michelle Wine Estates - enters its fourth decade of winemaking, they remain committed to crafting exceptional wines that reflect the rich history of the brand and the prestige of the Oregon wine region in general. The winery remains dedicated to producing world-class Pinot Noir available across all price points, making something for just about everyone.

Erath winemaker Gary Horner excels at everything Pinot Noir, making three distinct varieties each harvest: The Oregon, Estate Selection and the coveted single vineyard Pinot Noir. Known as one of the regions best Pinot Noir producers, almost two-thirds of the wine produced at Erath is Pinot Noir, though they also produce Pinot Gris, Pinot Blanc and select quantities of Dry Riesling, Dry Gewürztraminer and Dolcetto.

The tasting room is located at 9409 NE Worden Hill Rd in Dundee  and is open from 11am - 5pm daily. You can also order online at www.erath.com  or by phone at (800) 539-9463.

80

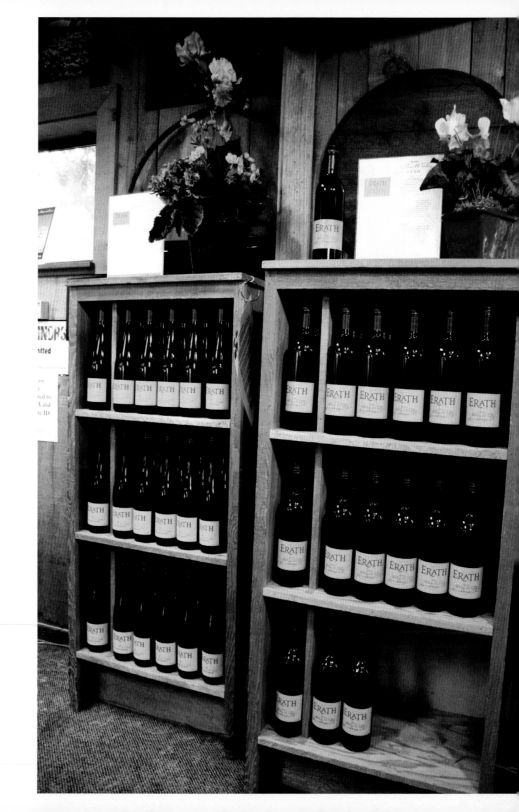

Just outside the town of Newberg, the tasting room at The Four Graces is set in a beautiful white farmhouse. Small and intimate with beautiful grounds, you will find it set at the base of the hill looking up at their vineyards. The grounds and picnic area outside are stunning and inviting.

We were honored to be whisked away with General Manager, Anthony Van Nice, through the winding hills of their gorgeous vineyards and up to the top where we enjoyed a glass of their fabulous 2006 Pinot Gris right next to the very vines that had produced this delightful nectar.

But who exactly are the Four Graces?

Owned by Steve and Paula Black, the Four Graces are actually their daughters Alexis, Vanessa, Christiana and Jillian. If you look very closely, you will find their names are featured around the upper labels of their bottles. Their son Nicholas is known as the "Keeper of the Four Graces" and has the unique honor of having his name featured on the bottles of the winery's Estate Pinot Noir. An intimate, family-owned and run operation with fantastic Pinot Noir and Pinot Gris, the Four Graces is not to be missed.

The tasting room is located at 9605 NE Fox Farm Road in Dundee and is open from 10am - 5pm daily. You can also visit them online at www.thefourgraces.com or by phone at (800) 245-2950.

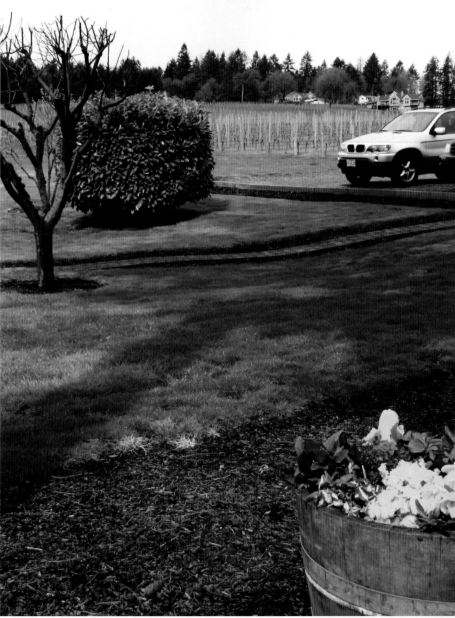

Right off the bustling 99W highway and through a beautiful white arbor walkway you will find the tasting room of Duck Pond Cellars. With beautifully landscaped grounds, the serenity of it all makes it easy to forget how easy it is to find.

Once inside, we were immediately greeted by the friendly staff and took a few minutes to marvel at their luscious gift shop before trying their wines. This fantastic gourmet gift shop offers many unique products including wine racks and totes, original artwork, hand painted pottery, gourmet cooking products, stemware, cookbooks and linens. Be sure to allow plenty of time to explore this gift shop as you're likely to get caught up in the experience of it all and completely lose track of yourself.

Eventually we found ourselves at the tasting counter where a myriad of selections awaited. While each wine was noteworthy, the 2006 Duck Pond Cellars Pinot Gris proved to be a standout - very enjoyable indeed.

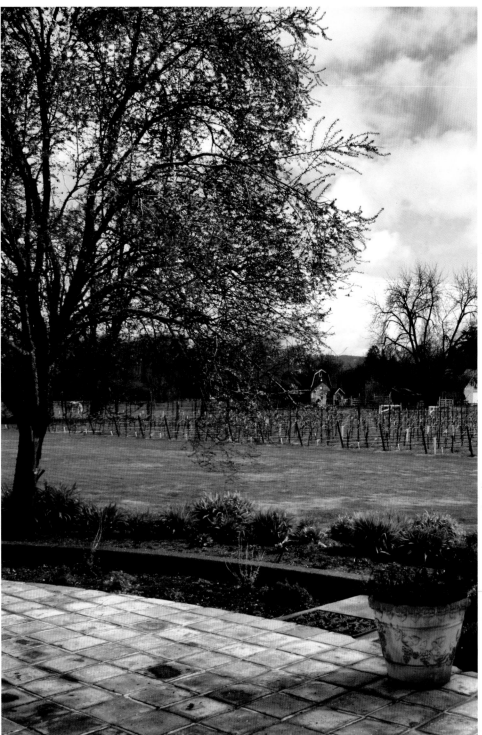

Duck Pond Cellars was founded in 1993 by the Fries family who have over 800 acres of vineyards in the valleys of northern Oregon and slopes of eastern Washington. They remain a family business dedicated to producing wines of premium quality at affordable prices.
Visit the winery at 23145 Hwy 99W S in Dundee.  The tasting room is open daily from 10am - 5 pm from May through September, and 11am - 5pm from October through April. You may also order online at www.duckpondcellars.com or over the phone at (800) 437-3213.

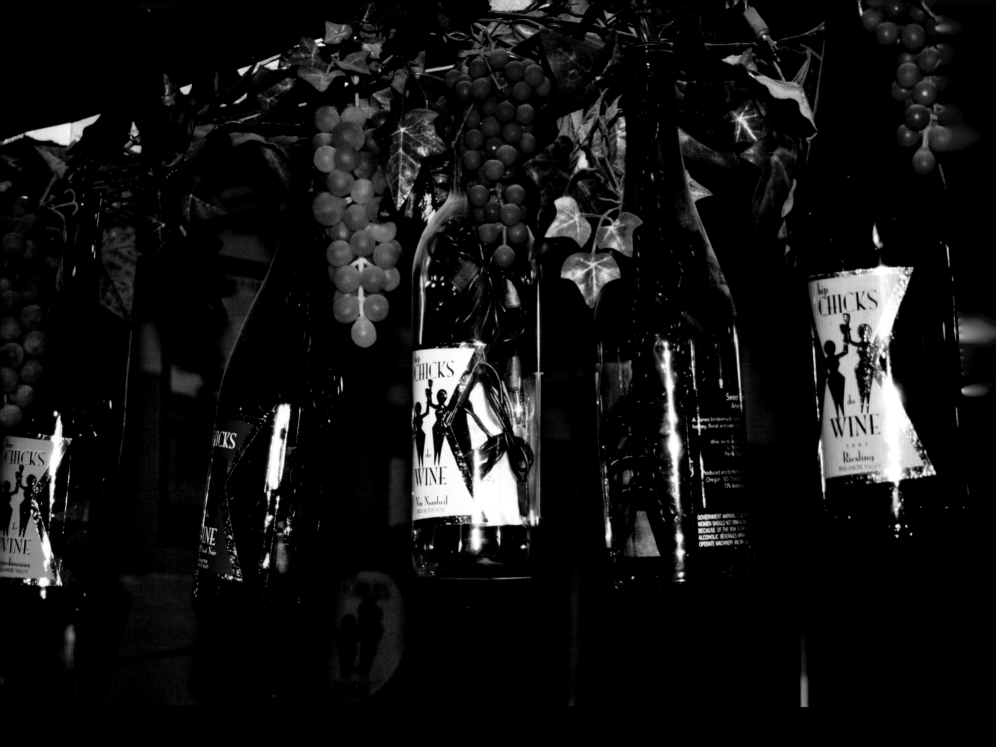

**Hip Chicks do Wine**

Imagine an industrial warehouse located in the heart of Portland, Oregon*...with a bright purple door. Welcome to one of the most innovative and yet fun wineries around, Hip Chicks do Wine. Wine makers Laurie Lewis and Renee Neely de-mystify the world of wine for a comfortable and fun experience. They believe wine is for everyday and not only for special occasions. As they say, "Open a bottle tonight! You made it through Tuesday...hurray!!"

*(Hip Chicks do Wine now has a tasting room open in Newberg!)

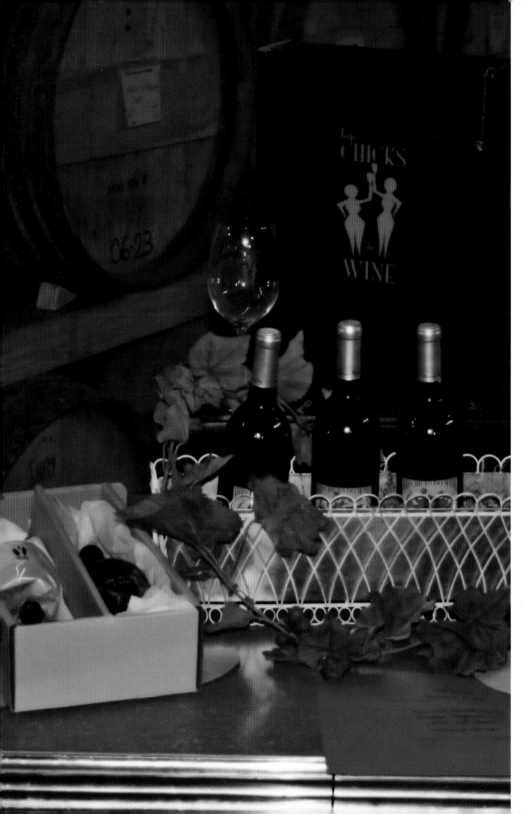

Purchasing grapes from both Oregon and Washington growers, the self-titled wine goddess (Laurie) and wine maven (Renee) embark upon making some incredibly fine wines. Syrah, Cabernet, Sangiovese, Malbec and Pinot Noir are aged ten month to two years in French oak barrels on site. This adds subtle complexity and keeps the wines approachable with no cellaring required. Muscat, Pinot Gris, and other whites are fermented on site in stainless steel containers, helping them maintain a fresh and fruity style.

All wines are handcrafted in very small lots. Producing 3,000 cases annually from their hip warehouse location, the Hip Chicks strive for a fruit forward style of wine that is very enjoyable from sip one. Their facility has an intimate tasting room that is open to the public during business hours and for special events. Their wines are also available for purchase online along with Hip Chick logo wear, wine glasses and fun gift items. Visit www.hipchicksdowine.com for the whole scoop and while you're there, sign up for their Wine Club. Hurry though, Tuesday's almost over!

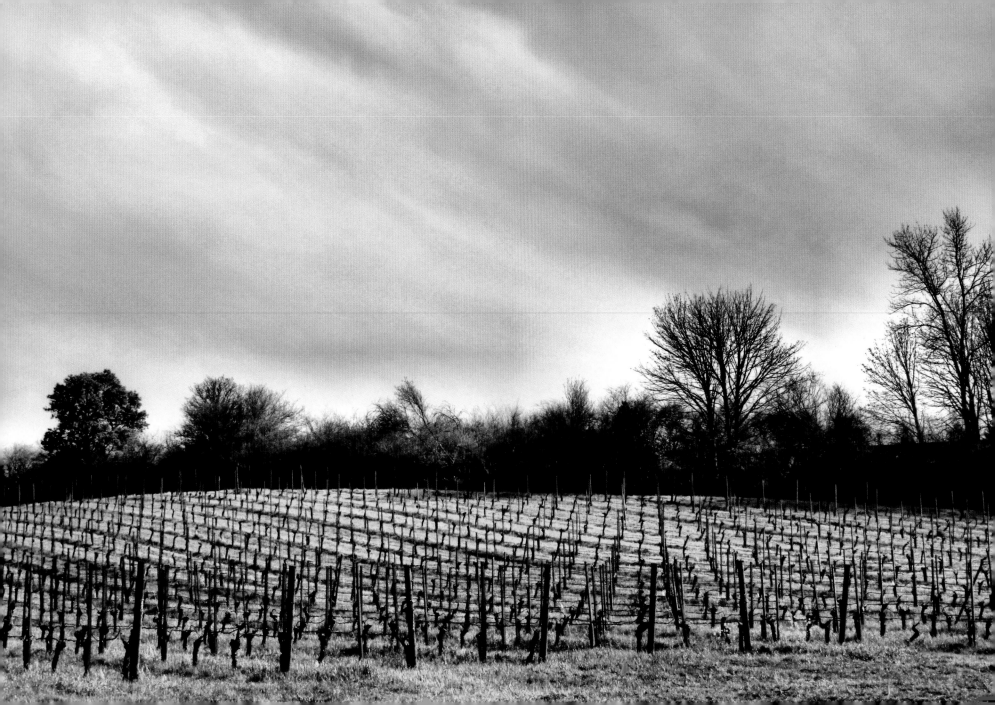

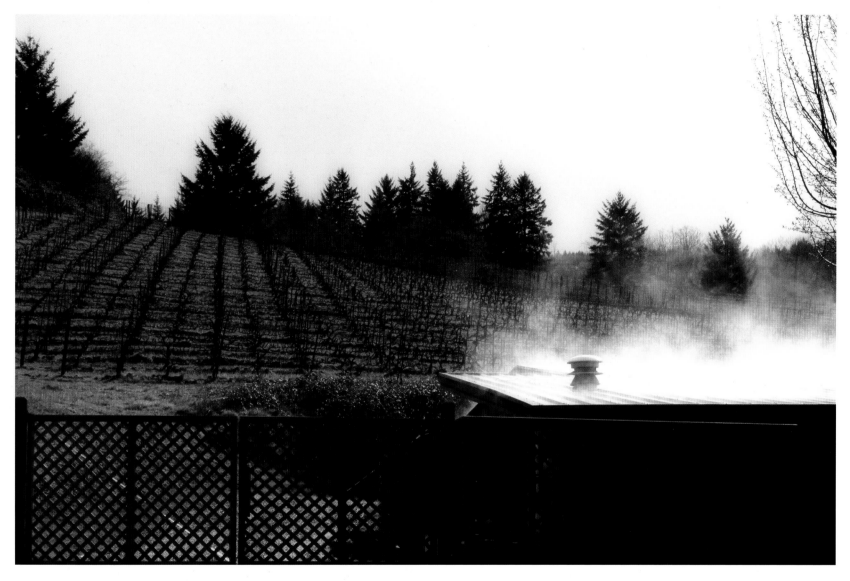

Pulling up to Rex Hill, the rolling hillside of vines immediately grabs your attention. The vineyard hill appears almost perfect, lined with trees and lush greenery. We happened to arrive just as the rain had stopped, so steam rose from the buildings, making for quite a gorgeous sight. Set in what used to be an old fruit & nut drying facility, Rex Hill Winery has a fascinating tasting room with all sorts of nooks and crannys to explore.

Almost as if drawn by an unseen force, we found ourselves congregating around the Essence Table. This table, cleverly anchored by an old wine barrel, contains wine glasses filled with many of the different fruits, nuts, and berries that you can experience in each sip of Oregon wine.

Rex Hill mixes up the ordinary by offering several wine education classes for all wine enthusiasts from the simply curious to the career driven. Exploring wines from all major growing regions from around the world, this program allows you to take the entire course or just audit certain sections on specific areas that pique your interest. Wine education is available to anyone interested on a first come first serve basis. Call the winery at (503) 538-0666 for more information.

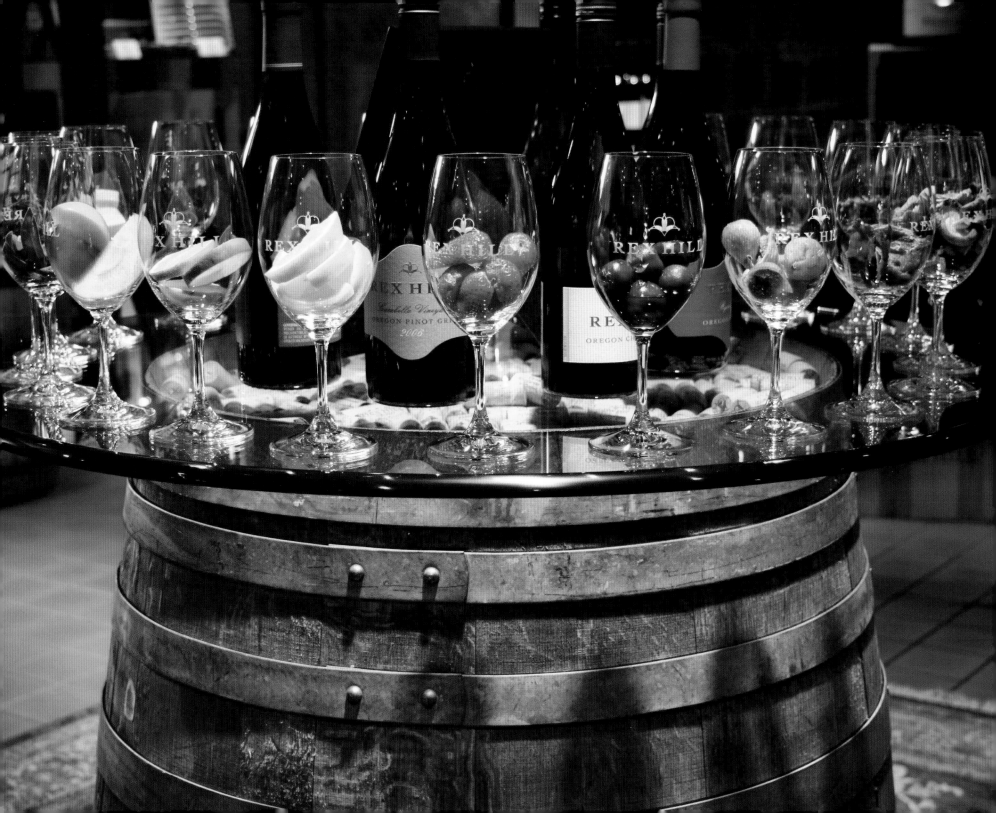

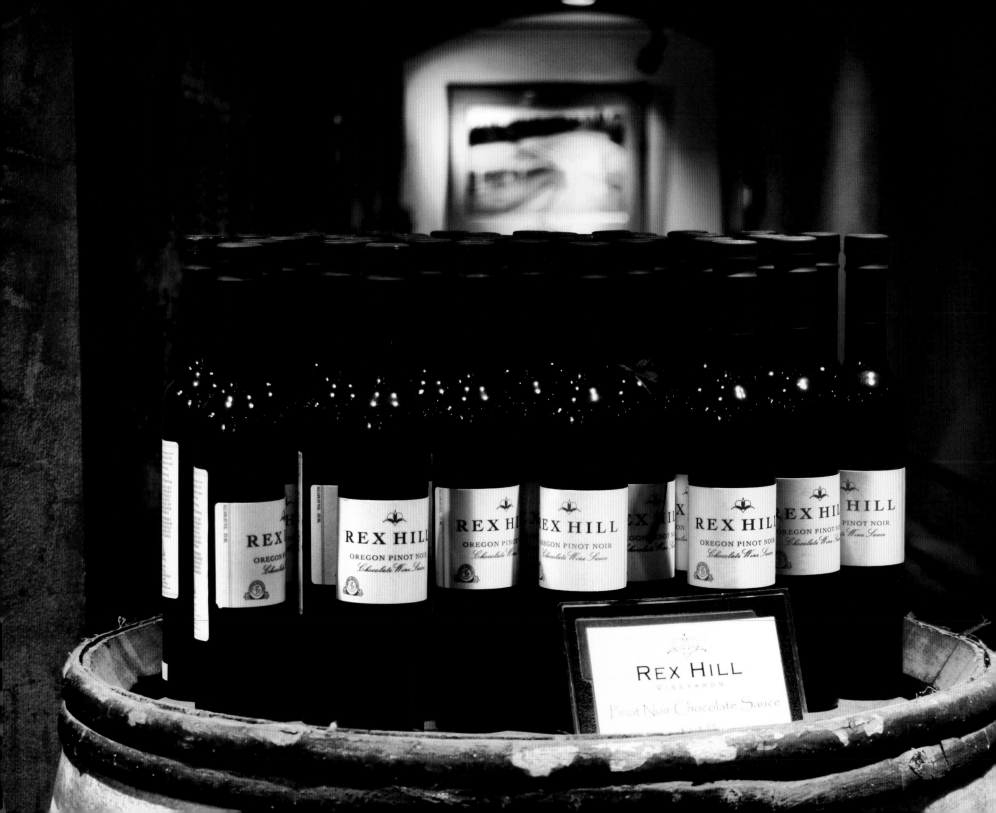

Rex Hill Winery is located at 30835 N Hwy 99W in Newberg. The tasting room is open daily 10am - 5pm. You can call the winery for information at 800-739-4455. If you are unable to visit in person, check out their online store at www.rexhill.com.